In the Inmost Hour of the Soul

Vox Humana

In the Inmost Hour of the Soul
Selected poems of *Marina Tsvetayeva*
Translated by *Nina Kossman*

On the Bridge
by *David Cope*

The Promise Is
by *Kip Zegers*

Quiet Lives
by *David Cope*

A Song Out of Harlem
by *Antar S. K. Mberi*

In the
Inmost Hour
of the Soul

Selected poems of

Marina Tsvetayeva

Translated by

Nina Kossman

Humana Press • Clifton, New Jersey

Some of these translations have appeared in: *City Lights, Vassar Review, Prism International,
The Raddle Moon, Gryphon, Russian Literary Triquarterly*

Translator's Introduction

"...I have no love for life as such; for me it begins to have significance, i.e., to acquire meaning and weight, only when it is transformed, i.e., in art. If I were taken beyond the sea— into paradise—and forbidden to write, I would refuse the sea and paradise. I don't need life *as a thing in itself*." This, written by Tsvetayeva in a letter to her Czech friend, Teskova, in 1925, could stand as an inscription to her life.

Marina Tsvetayeva was born in Moscow on September 26, 1892. Her father, a well-known art historian and philologist, founded the Moscow Museum of the Fine Arts, now known as the Pushkin Museum; her mother, a pianist, died young, in 1906. Marina began writing poetry at the age of six. Her first book, *Evening Album*, contained poems she had written before she turned seventeen, and enjoyed reviews by the poet, painter, and mentor of young writers, Max Voloshin, the poet Gumilyov, and the Symbolist critic and poet, Valerii Bryusov. Voloshin and Gumilyov welcomed the seventeen-year-old poet as their equal; Bryusov was more critical of her, though he too, in his own belligerent way, acknowledged her talent.

In 1912, Tsvetayeva married Sergei Efron, whose high-mindedness and chivalry she glorified in many poems; later that year her daughter Ariadna (Alya) was born. Though still a schoolboy, Sergei seemed to belong among the Romantic heroes who inspired Tsvetayeva at different points of her youth —Napoleon, Rostand, Don Juan, André Chenier. Her passionate search for perfection in art, in men, and in real or literary heroes of the past is best summed up in her own words: "Literature is propelled by passion, power, vitality, partiality."[1]

During the Russian civil war, Sergei Efron served on the side of the Whites. Stranded in Moscow with their two little daughters, Tsvetayeva wrote to him: "If God performs a miracle and leaves you among the living, I will serve you like a dog." After the terrible hungry years in Moscow, where her youngest daughter died of malnutrition, Tsvetayeva emigrated, following her husband first to Czechoslovakia (via Berlin), then to France.

Her collection of poems, *Versts I*, was published in Moscow the year she emigrated (1922). It was this book that started a correspondence between Tsvetayeva and Pasternak —he admired *Versts*, while she extolled his new collection of poems, *My Sister, Life*. One more poet joined this lyrical correspondence for four months in 1926: Rilke, the German poet, worshiped by Tsvetayeva and Pasternak as the very incarnation of poetry. Tsvetayeva considered Pasternak and Rilke "the only equals in strength" she ever met.

Despite the poverty in which she lived there, it was in Prague that Tsvetayeva wrote some of her most accomplished lyric poems, printed in Paris under the title *After Russia. 1922–1925*. Other books published by Tsvetayeva in her emigré period include *Parting* (Berlin, 1921); *Poems to Blok* (Berlin, 1922); *Craft* (Berlin, 1923); *Psyche* (Berlin, 1923).

In 1925 her son Mur was born in the tiny Czech village, Vsenory. That same year the family moved to Paris where, in addition to poverty, they suffered isolation from the emigré literary community. In her 1933 letter to her friend George Ivask, the emigré poet, she wrote: "...My husband is ill and can't work. My daughter earns five francs a day knitting bonnets, and on this four of us...live, that is, slowly starve to death." Tsvetayeva was not exaggerating, but stating a fact. Her literary income amounted to hardly anything: even the more liberal emigré publications stopped publishing her work since it did not serve any of the political/religious dogmas propagated by the various literary cliques that controlled the different presses. Besides, her husband's pro-Soviet sym-

pathies began to be apparent. At the time, Tsvetayeva did not yet know that, already working for the Soviet secret police, Efron had participated in planning the murder of a former secret police agent, as well as that of Trotsky's son. Her daughter, Alya, had already gone back to the Soviet Union; Efron, too, eventually returned there, having escaped through Republican Spain. Despite the shock she experienced upon learning of her husband's political activities in 1937, Tsvetayeva considered it her duty to join him and her daughter in Russia (1939). Though ostracized by the emigrés in Europe, she had few illusions about what life in the Soviet Union had to offer her. Rereading the diary in which she wrote that she would serve Efron "like a dog," she added, on the same page: "And here I'm going—like a dog (21 years later)."

Tsvetayeva and her son arrived in Moscow on June 18, 1939. Though exposed as a Soviet agent by French and Swiss authorities, Sergei Efron, upon his return to Moscow, was suspected of working against the Soviet government; he was arrested not long after Marina's arrival. Her daughter was also arrested and sent to a labor camp. Tsvetayeva wrote in her diary: "I have been trying death on for size. It's all ugly and terrifying. To swallow is disgusting, to jump is inimical, my inborn revulsion to water. I do not want to frighten (posthumously)...I do not want to *die*. I want *not to be*. Nonsense. As long as I'm *needed*...but God...how little I can do! To live my life out is to chew bitter wormwood to the end."[2]

The exact date of Efron's execution in unknown, but it might have happened in the summer of 1941. On June 22nd of that year the Germans attacked Russia; soon afterwards, Tsvetayeva and her son Mur were evacuated from Moscow, where she had been shunned because of her emigré past and the arrests of her family members, to the remote town of Elabuga. There, having no money to provide food for her son and herself, she made a trip to a nearby town, Chistopol, where she applied to work as a dishwasher in a writers' cafe-

teria. On August 31, she hanged herself. Nobody went to her burial; her son volunteered for the front and was soon reported killed.

In her 1933 letter to Ivask, Tsvetayeva had written: "No, my friend, neither with those, nor with these, nor with third persons, and not only with 'politicians,' but also with writers, I am—*not*; with no one, alone, my whole life through, without books, without readers, without friends—without circle, without hearth, without protection, belonging nowhere, worse than a dog."[3]

Many point to Tsvetayeva's haughtiness, her difficult character as the reason for her isolation; others say it was caused by her having been caught between two warring camps. In one of his poems, Mandelstam compared his time to a wolfhound; Tsvetayeva said she was born outside of time, and therefore the present had no place for her. The only country to which she was totally devoted was that of her imagination, her art: "I never, no matter what, cared for anything but poetry!" she said to Ivask. To those who would see this as egocentrism, there was an answer: "The only task of man on earth is truth of self; real poets are always prisoners of themselves; this fortress is stronger than that of Peter and Paul."[4]

Tsvetayeva's poems plunge the reader into an atmosphere of emotional intensity, limitless feelings ("this limitlessness in the world of limits!"[5]), constant dramatic conflicts with the norms of the surrounding world. Never calm and contemplative, Tsvetayeva's poetry is work of dynamism, strength, and a rapturous, "heathen" love of life. "To love the sea means to become a fisherman, a sailor, and still better—a Byron (a sailor and a singer, in one!). To lie by the sea...does not mean to love it."[6]

In her life this immensity of feeling had disastrous results: people were "horrified by the dimensions of emotions they aroused in me."[7] Yet the nature of Tsvetayeva's feelings was not what it often seemed to the men who were targets of

her obsessions. In her letter to Pasternak (July 10, 1926), she wrote of "the ancient, insatiable hate of Psyche for Eve—Eve, of whom there is nothing in me. Of Psyche—everything." In the same letter she wrote: "I do not understand flesh as such and deny that it has any rights....Do you know what I want—when I want?...The most remote headland of another's soul—and my own. Words that one will never hear or speak. The improbable. The miraculous. A miracle." And in her letter to Rilke (August 22, 1926): "Love lives on words and dies of deeds....The word, which for me is already the thing, is all I want....The farther from me—the farther *into* me. I do not live in myself, but outside myself. I do not live in my lips, and he who kisses me misses *me*."[8] This seems to contradict her definition of love as an active, real force, but the contradiction is illusory. The "love" that Tsvetayeva spoke of existed in the world of the spirit, in the world where the unattainable, the impossible was real. For Tsvetayeva it was a given that the touching of words was as real as the touching of hands.

The "elements," i.e., a spiritualized Nature, for Tsvetayeva were synonymous with soul. "Nothing touches me but Nature, i.e., the soul; and the soul, i.e., Nature," she wrote to her friend Teskova on December 12, 1927. In her work the intensity of thought, speeding upon the wings of emotion, proves the fearlessness of her confrontation with (and the expression of) the elements, her irrevocable refusal to don the "armor," i.e., to appear before a reader (and the elements) arrayed in the psychological defenses of feminine lyrics—melodiousness and languor, both variations of the poetic posturing that uses feeling (i.e., what poetry is said to reveal) as a psychological defense (i.e., conceals the self, in life or art). This paradox of self-revelation/self-concealment is most conspicuous in the assortment of "poses" that lyric poetry as a genre has at its disposal: e.g., a pouring forth of feeling can assume the mincing posture of more traditional feminine love lyrics. It is clear that the force of Tsvetayeva's emotions cannot be confined by conventional strictures. Yet even her

dramatic and hyperbolic speech cannot fully express the power of her feelings: "The limitlessness of my words is but a weak shadow of the limitlessness of my feelings."[9]

For Tsvetayeva, creating is like giving herself over to a fever: "There is no way to approach art: it takes hold of you." "Being creative means being obsessed." Yet Tsvetayeva developed a unique poetic form. Certainly its mastery required not only psychological courage and inspiration, but also the iron discipline of a craftsman. In her essay, "Art in the Light of Conscience," she defines genius as "the highest degree of susceptibility to inspiration" and "control over the inspiration." "Creative will is patience," she says elsewhere.

Her style abounds in peculiarities, some virtually untranslatable. The dynamism of her speech is unprecedented, yet her lines speed forward almost without the help of verbs, generally perceived as carriers of motion, action. Seething with energy, her lines nearly burst at the seams, and her dashes are those very seams that, strained to the utmost, hold together the contents of her lines. Borrowing from Tsvetayeva her habit of speaking metaphorically, we may say that, having discarded wheels (i.e., verbs), which guaranteed her swift movement, but also weighed her down, her verse soared.

An experienced master of sophisticated poetic form, Tsvetayeva sees form as only the means, never the aim, of poetry. "As though words gave birth to words, rhymes to rhymes, poems to poems!" she argued with formalists. She considered Boris Pasternak the best modern Russian poet because his contribution was "not a new form but a new essence, and consequently, a new form." For Tsvetayeva, it is the essence that counts in poetry and the essence that dictates new poetic form, not the other way around. As Orlov pointed out in his introduction to the 1965 Soviet edition of her work, for Tsvetayeva the essence of poetry lies in its ability to render, through words, the structure of a poet's soul. It is the

"structure of the soul" that must be different; innovative form will follow.

She saw mere estheticism as an unpardonable sin against true life and true art. True life means a complete surrender to the elements. True art comes as a result of this psychological openness to experience; it is the voice of the elements speaking through the poet. Tsvetayeva had the most profound hatred for verbal decorators, i.e., makers of literature she ironically referred to as belle-lettres. Her concern was with life, not literature. "Everyone has a place under the sky—a traitor, a rapist, a murderer—but not an esthete! He does not count! He is expelled from the elements, he is a zero!"[10] If Tsvetayeva's psychological courage is defined as the ability to surrender one's self wholly to another—a person, a poem, the elements in each (a testimony to her generosity of spirit), then the transmutation of her own element into that other (which, in turn, becomes hers) is the essence of Tsvetayeva's poetry. Her words are emotional, almost physical gestures that heighten the intensity of her appeals to the world, the Romantic past, God, a lover, a child—who is (and is not) herself. As she wrote in her letter to Rilke on August 26, 1926, she demands of poetry "the truth of this moment."

Tsvetayeva's powerful language is notoriously difficult to translate precisely because "the rhythms that inhabited her soul," as Pasternak put it, were so Russian, so close to the folklore, and yet so daringly her own. In translating these poems, my goal was to reproduce Tsvetayeva's intense voice, to carry through into English the energy of the original poem. Tsvetayeva's intensity, which in Russian perfectly agrees with her pattern of rhyme and rhythm, is bound to be lost in any translation in which rhyme and rhythm become the primary concern. Nonetheless, there are in this collection a few metrically translated poems; it seemed to me that those particular poems

were amenable to, and indeed would benefit from, just this sort of treatment. In all the rest, I tried to create readable English poems rather than attempt the next-to-impossible task of maintaining her original schemes of rhyme and meter. Regrettably, there were wonderful poems that I had to omit because they seemed not to lend themselves to translation at all. In the end, I do not claim success for my venture; that is for the reader to decide. My only hope is that at least some of Tsvetayeva's greatness of spirit and art, some of her special intensity shines through.

I would like to thank my friend Wayne Pernu for the numerous suggestions he provided while I was working on the final versions of these poems.

Nina Kossman

Notes

[1] Mark Slonim, *Soviet Russian Literature: Writers and Problems, 1917–1967* (Oxford University Press, 1967), p. 265.

[2] Simon Karlinsky, *Marina Tsvetayeva. The Woman, Her World, and Her Poetry* (Cambridge University Press, 1985), p. 236.

[3] From Robin Kimbal's Foreword to the *Demesne of the Swans* (Ann Arbor: Ardis, 1980), p. 26.

[4] Mark Slonim (1967), p. 265.

[5] A line from Tsvetayeva's 1923 poem (the cycle "Poet," #3).

[6] V. Orlov's Preface to *Marina Tsvetayeva, Izbrannye Proizvedenia* (Moscow-Leningrad: Sovyetskii Pisatel, 1965), p. 37. This and subsequent quotations are from Tsvetayeva's archives (draft notebooks, drafts of letters, etc.), cited by V. Orlov.

[7] Karlinsky (1966), p. 58.

[8] Boris Pasternak, Marina Tsvetayeva, Rainer Maria Rilke, *Letters. Summer 1926* (New York: Harcourt Brace Jovanovich, 1985), pp. 177, 179, 202.

[9] Orlov, p. 38.

[10] Orlov, p. 39.

Contents*

*Titles in boldface are those of Tsvetayeva; lightface titles are based on the first lines of the poems.

You, rushing past on your streets

You, rushing past on your streets
To some dubious magic you've tasted,
If only you knew how much heat,
How much lifeblood I've already wasted,

How much heroic passion I threw
At a random shadow or rustling...
How each time my heart flamed anew
And spent its powder for nothing.

O trains flying into the night,
Making off with the sleep of the station...
But I know nevertheless that you might
Never answer—if you heard it—the question:

Why are my words so strong and so sharp
To my cigaret's perpetual smolder.
How much gloom and imperiling dark
In the light-haired head on my shoulders.

1913

The war, the war

The war, the war! The incense at the altars,
The chirring spurs.
But I don't give a damn for the tsar's problems
And people's wars.

It's as if on a slightly frayed tightrope
I dance to tiny tunes.
A shadow of someone's shade, I am a sleepwalker
Of two dark moons.

1914

The leaves have fallen upon your gravestone

The leaves have fallen upon your gravestone.
The smell of winter.
Listen my dead one, listen my only one:
You are still mine.

Still laughing! In that dear, traveler's cloak!
The moon is high.
Still mine—as irrevocably and inescapably
As my own hand.

Again in the morning, I will come with a bundle
To the hospital door.
You have merely left for the warmer countries,
For the far shores.

I kissed you! I witched you!
I laugh at the afterlife's dark.
Your death is a lie. I expect you from the station—
Home.

Let the leaves fall, let the words be washed off
The funeral wreaths.
And if you are dead for the rest of the world,
I am dead, too.

I see you, I sense you—you are everywhere.
What nonsense, your funeral wreath!
I have not forgotten you, I won't forget you
Forever and ever.

I know the waste of such promise.
I know it's all in vain.
A letter to infinity—a letter to the cosmos—
A letter to the void.

1914

The fatal volume

The fatal volume
Holds no temptation for
A woman: *Ars Amandi*
For a woman is all of Earth.

The heart is the most faithful
Of all love potions.
From her crib on, a woman
Is someone's deadly sin.

Ah, the sky is too distant!
Lips are closer in the dark.
Do not judge, God! Never
Were you a woman on Earth.

1915

Two suns are cooling

Two suns are cooling—My God, have mercy!
One in the sky, the other in my chest.

How these suns—can I forgive myself?—
How these suns have been driving me mad!

And now, both are cooling—their rays don't hurt.
And the hotter one will be first to cool.

1915

After a sleepless night

After a sleepless night my body grows weaker,
Becomes sweet and no one's—no longer mine.
In the slow veins arrows still flicker,
And like a seraph, I smile at passers-by.

After a sleepless night my arms grow languid;
Friend or foe, my indifference is complete.
A full rainbow unfolds from a chance sound
And the scent of Florence stuns in a frozen street.

My lips lighten tenderly, shadows golden
Round my sunken eyes. It is the night that lit
This luminous face. And when the dark night's over,
Only our eyes stay darkened, that is all.

1916

Sweetly—sweetly

Sweetly—sweetly, thinly—thinly
Something whistled in the pine.
In my dream I saw a baby
With midnight-colored eyes.

Still, hot resin keeps dripping
From the little scarlet pine.
Sawed apart, my heart is ripping
In this splendid night, all mine.

1916

Black as an iris

Black as an iris, as an iris sucking up the
Light—I love you, sharp-sighted night.

Let me sing you and celebrate you, O ancient mother
Of songs who bridles the earth's four winds.

Calling you, glorifying you—I am nothing but a
Shell in which the ocean is not yet silenced.

Night! Enough of looking into human eyes!
Reduce me to ashes, blackest of suns—night!

1916

To kiss one's brow

To kiss one's brow is to smooth away worry.
I kiss your brow.
To kiss one's eyes is to lift insomnia.
I kiss your eyes.
To kiss one's lips is to quench thirst.
I kiss your lips.
To kiss one's brow is to erase remembrance.
I kiss your brow.

1917

I came in

I came in; I said to him: Good day.
It's time to go home, King, to France.
Again I will be offering to you your kingdom,
And, Charles the Seventh, you'll hoax me again!

Do not expect, miserly unhappy prince,
Bloodless prince who never held his back straight,
That Joan would fall out of love—with voice,
That Joan would fall out of love—with sword.

And there was Rouen, and in Rouen the old market...
—All will come to pass again: the steed's last glance,
The first crackle of the innocent dry branches,
The first splash of the pinewood flame.

My winged friend, from behind my back,
Will whisper once again: Be patient, sister!—
When my silver armor will glare
With the pinewood blood of my fire.

1917

The New Year's Eve

The New Year's Eve I spent alone.
I, the rich one, was the poorest.
I, the winged one, was the accursed.
Somewhere many people tightly held
Hands, drinking their old wine.
And the winged one was the accursed.
And the only one was alone.
Like the lone moon, in the window's eye.

1917

I am not an impostor

I am not an impostor, for I came home.
I am not a maid: I do not ask for bread.
I am your passion, your Sunday rest,
Your seventh day, your seventh heaven.

There, on earth, they gave me nothing
And hung millstones around my neck.
—Don't you recognize me, beloved?
I am your swallow: Psyche.

1918

Here, darling, take these rags

Here, darling, take these rags
That once were tender flesh.
I tore it up, I wore it down—
All I have now are these two wings.

Dress me in your splendor.
Save me and forgive.
Take away to the sacristy
Those poor rotting rags.

1918

Words are inscribed in the black sky

Words are inscribed in the black sky,
And the beautiful eyes go blind...
And the deathbed is no longer terrible,
And the lovebed is no longer sweet.

Sweat from writing—sweat from ploughing.
We know another ardor:
Weightless fire dancing around the curls—
The breeze of inspiration.

1918

I am. You shall be.

I am. You shall be. Between us—chasm.
I drink. You thirst. All talk is futile.
Ten years—a hundred thousand years
Part us. God does not build bridges.
Be—This is my commandment. Let me pass
And not disturb your growth with my breathing.
I am. You shall be. In ten years' time
You'll say: I am—I will say: I was.

1918

I will tell you about the great hoax

I will tell you about the great hoax.
I will tell you how the fog falls on
Young trees, old stumps.
I will tell you how lights go off
In houses, how—a traveler from Egypt—
A gypsy blows, under a tree, into his narrow pipe.

I will tell you about the great hoax:
I will tell you how a knife is squeezed
In a narrow hand, how the wind of the ages
Lifts up the curls of the young, beards of the old.

The rumble of the ages.
The clatter of hoofs.

1918

Spurned by my lover

Spurned by a lover, these hands
Now serve the needs of the World.
Wife of the World! With this mirthless title
We were crowned by the lyre.

There are many uncalled to the tsar's feast.
Songs are called for at dinner.
The world will yet outlive a lover.
Our work is not wasted here.

1918

Dying, I will not say

Dying, I will not say: I have been.
No regrets; I've no one to blame.
There are, in the world, more important things
Than storms of passion and romantic exploits.

You, who beat your wing against this chest,
Young perpetrator of inspiration—
I command you: be.
I will remain compliant.

1918

I am paper to your pen

I am paper to your pen;
I accept it all. I am a white page;
I am a keeper of your goods.
I will return it all, return it hundredfold.

I am country; I am black soil.
You are to me, rain and a ray.
You are my Lord and Master, while I am
White paper and black earth.

1918

Your soul is close to mine

Your soul is close to mine
Like the right and the left hand.

We are joined blissfully and warmly
Like the right and the left wing.

But the storm begins, and a chasm's laid open
Between the right wing and the left.

1918

Poems grow like stars

Poems grow like stars, and like roses—
Like beauty not meant for home.
And to the wreaths and the apotheosis
The same answer: Where are they from?

We sleep—and then, as through the cobbles—
The heavens'-guest and its four petals loom.
O, world, take note! A sleeping bard discovers
The law of star, the formula of bloom.

1918

Bring to me all that's of no use to others

Bring to me all that's of no use to others:
My fire must burn it all!
I lure life, and I lure death
As weightless gifts to my fire.

Fire loves light-weighted things:
Last year's brushwood, wreathes, words.
Fire blazes from this kind of food.
You will rise from it purer than ash!

I am the Phoenix; only in the fire do I sing.
Provide for my miraculous life!
I burn high—and I burn to the ground.
From now on let your nights be light-filled.

The icy fire—the fiery fount.
I hold high my tall form,
I hold high my high rank
Of Confidant and Heiress!

1918

The sun is one, but marches through all lands

The sun is one, but marches through all lands.
The sun is mine. I will not share my sun.

Not an hour of it, nor a ray, nor a look. Never. With no one.
Let all cities perish in their perpetual night.

I'll cup it in my hands; I'll forbid it to circle.
Never mind if I burn my hands, my lips, and my heart.

Should it vanish in eternal darkness—I'll stalk its tracks.
My sun! I will not share you with anyone.

1919

Two trees

Two trees long to be near each other.
Two trees. Across the street—my house.
The trees are old. So too is my house.
Were I not young myself, I would not
waste pity on other people's trees.

The one that's smaller, like a woman
stretches out its arms, stretches out
its last veins—it pains me to see
how it reaches out to that other one,
that older, stronger one—who knows—
the more wretched of the two...

Two trees—in the sunset ardor,
In the rain—in the snow, as well—
Forever so: one with the other.
Such is the law: one with the other.
The law is one: one with the other.

1919

God, I live!

God, I live!—God, it means you haven't yet died!
God, we are allied, you and I.
But you are a glum old father,
And I, a herald with a horn.

God! Sleep in your azure darkness.
While I still walk the Earth,
Your house stands. I face the tempests,
I am the drummer for your troops.

I am your bugler. It is I who heralds
The coming of evening and of dawn.
God! My love is not a daughter's.
I love you like a son.

Look: my tent keeps glowing
Like an ever-burning shrub.
I will not change places with a seraph.
I volunteered for you, God.

Give me time: soon every village
Will learn of the tsar-maiden. Till then—
To others, I am a garret singer,
And you, an old king of clubs.

1919

I am happy to live impeccably and simply

I am happy to live impeccably and simply.
Like a calendar—a pendulum—like the sun.
A worldly recluse of shapely size,
As wise as any creature of God.

To know: spirit is my helpmate, and spirit—my guide.
To enter without a word, like a ray and a look.
To live as I write: tersely, impeccably—
The way God commanded and friends don't approve.

1919

My way does not lie by your house

My way does not lie by your house.
My way lies by no one's house.

And yet, I lose my way often
(Especially—in the spring!)
And yet, I long for people
Like a dog under a full moon.

A coveted guest everywhere,
I let no one sleep.
I play dice with a grandfather;
With a grandson I sing.

Wives aren't jealous of me.
I am but a ray and a look.
Not a single lover
Has built a castle for me.

Your unasked-for gifts
Make me laugh, tradesmen!
I myself build at night
Bridges, chateaus.

(Don't listen to what I say.
Women, they always babble!)
In the morning, I myself will destroy
My own creation.

Castles—like sheafs of hay—like nothing at all!
—My way does not lie by your house.

1920

To you, who bid farewell to love

To you, who bid farewell to love—
Farewell to you.
I had your fill of your offenses.
I read in your eyes,
Like a scathing Biblical Psalm,
"The evil passion!"

In the hands that bring you food
You read flattery.
My laughter—O jealousy of other hearts!—
Grates on your ears
Like a tambourine of lepers.

From the way you grasp your pick
In your hands—so as not to touch
Mine (are not hands also flowers?)
It is as clear to me as night
That in your flock there was no
Sheep blacker than I.

There is an island—thank God!—
Where I don't need a tambourine,
Where black wool
Hangs from every fence. Yes—
There are in the world black flocks,
Other shepherds.

1920

There is a whole tribe of them pining after me

There is a whole tribe of them pining after me.
But it might be easier if I were damned.
And maybe these gypsy patches
On my humble dress

Are no less than unalloyed gold,
Than the white armor confronting
The face of judgment.

The dancer's task is not to falter on the tightrope.
The dancer's task is to forget having known
Substance

Other than air under his winged feet.
Leave him. Like you, he is but an envoy
Of his god.

1920

Nailed to the Pillory...

I

Nailed to the pillory of shame
Of the ancient conscience of the Slavs,
Snake in my heart, stigma on my brow,
I still maintain that I am innocent.

I still insist that I share the peace
Of the pious receiving the Eucharist,
That it is not my fault my hand
Is held out in the streets for happiness.

Sort out all this trash.
Tell me—or am I blind?—
Where is my gold? Or my silver?
There are only ashes in my hand.

And this is all, with flattery and prayer,
I have received from those who are so happy.
And this is all that I will carry
Into the land of silent kisses.

1920

Nailed to the Pillory...

II

Nailed to the pillory, I will still
Say that I love you.

That, in her womb-thoughts, no mother
Could look at her child as fondly.
That, as you keep busy, I would not want
Just to be dying, but to die for you.
You'll not understand—my words are feeble—
That the pillory is too feeble a rack.

That, had troops entrusted me with their flag,
Were you to appear with the flag of the foe,
My hand—numb as the pillory—
Would at once let go their flag.
So, having trampled my highest honor
Under your feet, lower than the grass...

Nailed to the pillory by your very hand,
Here I stand—a birch, alone in a field.

This pillory—my obelisk; this murmur—not the crowd
But the pigeons', cooing in the early sun.
Having given everything, I will not trade this black
Pillory, not even for the red halo of Rouen.

1920

You wanted this

You wanted this. So. Alleluia.
I kiss the hand that strikes me.

I pull to my chest the hand that pushed my chest away.
Stunned, you will hear only silence.

So that later, with an indifferent smile, you'd say:
"My woman grows tame."

Not for a day—for centuries
I draw you to my chest, the monk's

Hand, cold until burning,
The hand—O Heloise—of Abelard.

In the cathedral thunder: to lash me to death—
You, whip soaring up like white lightning!

1920

Neither stanzas nor stars will save me

Neither stanzas nor stars will save me.
This is a reprisal
For every time when,

Straightening my back above a stubborn line,
I looked only for stars, not eyes
Above my ample brow—

Accepting your unflagging rule on faith,
Not even one minute, O my fair Eros,
Was laid to waste without you—

At night, amid the solemn mists,
I never asked for lips, only rhymes
From the lovely red lips.

This is a reprisal for having been like snow
Before the most vicious judges, for the unending apotheosis
Beneath my left breast.

Face to face with the budding East
I looked only for dawns, never roses
Upon my ample brow.

1920

Earthly Name

When parched with thirst, give me water,
One glass, or else I'll die.
Persistently—languidly—melodically—
I pledge my feverish cry

Repeated at length—yet still more fiercely,
Once more—again—
Tossing all night long for sleep,
Aware all sleep is spent.

As if the fields were not abounding
In herbs that grant relief.
Persistently—senselessly—redundantly—
An infant's babbled repeats...

Thus, each utterance more final:
Noose—at the neck joint...
And if it's but an earthly name I'm moaning—
That's not the point.

1920

Roland's Horn

Like a sweet fool prattling his merciless handicap
I give you the story of my orphanhood...

A seraph by his host, a prince by all his kin,
Each is attended by the thousands just like him.

So that were he to stagger, he'd be carried along
By a living wall, the thousands to follow.

A captain is proud of his troops, a devil of his fiends,
The hump adheres to a fool, the rabble escorts a thief.

Whereas I, worn out at last by my life's only purpose:
To fight, and by the knowledge: I am alone, always,

Except for the Philistine's jeer and the imbecile's catcall—
Alone—among them all—for all—against all—

I stand here, petrified at take-off, sending
This blaring call into the void of heaven.

And this fire inside my chest has sworn
That a Charlemagne has yet to hear you, Horn.

1921

Soul unacquainted with limits

Soul unacquainted with limits,
Soul of a fanatic, of a Khlyst,*
Longing for a whip.
Soul soaring towards the hangman
Like a butterfly out of its chrysalis.
Soul that never swallowed the insult
Of this age no longer burning witches.
Steam rising from a hair-shirt
Lashed by the long tarred whip.
The gnashing teeth of a heretic,
—the sister to Savonarola—
Soul worthy of a stake.

1921

*A member of a Russian sect that practiced self-flagellation

Shaggy star

Shaggy star
Rushing nowhere
From terrible where
Stray sheep invading
The gold-fleeced flocks
—Like jealousy—
Shaggy star of the ancients.

1921

How they flare up

How they flare up, like wind-fallen branches
In the town squares at night: the sacred relics of blood.
What are our genealogies and our prowess
To tenderness' self-imposed decree?

With what solemn languor
The high-flown ramshackles fall.
Our ancestors' valuables
Under pity's self-imposed assault!

Yet, simpler: bury the brow in the hollow of the palm,
Aware of crudeness and inevitability—
Down the slanting, steadfast,
Implacable slope of love...

1921

Slowly, with a careful thin hand

Slowly,
With a careful thin hand I'll unravel the tangles:
The little hands; and, obedient
To my horse's neighing, my riding dress
Will rustle down the ringing, empty stairs of parting

He stamps his feet and neighs—
The winged one,
In the aureole stairway. Dawn burns my eyes.
Little hands, little hands!
You call me in vain:
The streaming stairs of Lethe part us.

1921

I know that mortal loveliness

I know
That mortal loveliness,
This charming
Carved chalice
Is no more ours
Than air,
Than stars,
Than nests
Hanging down in the dawn.

I know
To whom the chalice belongs!
But, place the swift foot forward; towerlike,
Invade the eagle's realm!
With your wing, remove the chalice
From the stern pink lips
Of God!

1921

In the garden

In the garden the unpicked grapes grew rusty;
The concubine slept, having tired of waiting.
Palestinian veins! Saul's ancient sorrow,
Heavier than tar, flows in you.

His mouth is blemished by a five-day wound.
King's blood, with the end in sight, how sluggish!
His food and drink for so long untouched;
His eyes for so long scanning the ground.

On his cheeks Jericho-roses are blazing.
His chest heaves like a furnace.
And Palestine's youth, their blood darkened,
Prolong the sigh Saul has bequeathed them.

1921

Pride and Timidity

Pride and Timidity, the two twin sisters,
Stood high above my cradle, united.

"Lift up your forehead!"—Pride has commanded.
"Lower your eye!"—Timidity whispered.

Thus do I pass by—lifting my forehead,
Lowering my eyes: Pride and Timidity.

1921

Praise to Aphrodite

I

Blessed are they, O Earth,
Who left your daughters for the battle and the race.
Blessed are they who went
To the Elysian Plain unlured by caresses.

Thus grows a laurel, hard-leaved and sober,
Laurel the chronicler, the spur to battle.
I prefer the cloudy cliffs of friendship
To the platitudinous sorrows of love.

1921

Praise to Aphrodite

II

The gods are no longer generous
On the shore of this *other* river.
Doves of Venus, fly
Into the sunset's wide gates.

Lying on cold sand,
I'll pass onto a day unmarked on the calendar...
Like a snake looking down on its old skin,
I have outlived my youth.

1921

Praise to Aphrodite

III

Hiding amid the forbidden boughs,
Your tender flock rumbles in vain.
I let the voluptuous sash fall;
Let fall the amorous myrtle.

With his blunt fatal arrow
Your own son freed me.
—Vanish like foam at the throne
Of my calm, froth-born goddess!

1921

Praise to Aphrodite

IV

How many, how many of them feed off your hands,
White doves and gray doves!
Entire kingdoms coo and dance
Round your lips, Baseness!

Still, the deadly sweat overflows
Your golden bowl.
Even the crested warrior clings
Like a white she-dove.

On an evil day each cloud
Grows as round as breasts.
Every innocent flower
Bears your face, Temptress!

Mortal whitewater, salt of the sea...
In whitewater and torture,
How long are we to heed your call
O armless sculpture?

1921

From the mind's dreams

From the mind's dreams, from the bile's rage,
Goddess of Faithfulness, keep your slave.

With hoops of steel bind tight her breast,
Goddess of Faithfulness, be her nest.

Remove from the shrub all flowers and pips,
Make her mouth numb, then seal her lips.

As safe as bone encased in a grave,
Goddess of Faithfulness, keep your slave.

To keep her loom humming without a stop,
Her lips must learn the law of the lock.

To have it inscribed on the stone of her grave:
"Only of Faithfulness was I the slave."

Her ribs to the post, with your sharpest stave,
Goddess of Faithfulness, now stab your slave.

1921

With such force has her hand grasped

With such force has her hand grasped
Her chin that her mouth twists in pain.
With such vividness envisioned the parting
That not even death may part them:

Thus, a flag-bearer abandoning his standard;
Thus, a mother at the scaffold hears: "Now!"
Thus, the concubine of a last monarch
Staring at the night with her last eyes.

1921

The Muse

She has neither rights, nor forebears,
Nor a handsome falcon.
She walks on—wrenches away—
So distant!

The gold-winged fire lit
Under her swarthy eyelids.
With her rugged hand
She takes and forgets.

Her skirt untucked,
Scraps laid bare.
Neither wicked, nor kind,
But merely distant.

Neither weeps, nor complains:
Draw her up close—she yields.
With her rugged hand
She gives and forgets.

Then, with the guttural
Spouting, with the screech...
Take care, O Lord,
Of this distant one.

1921

Orpheus

So they drifted: the lyre and the head,
Downstream, towards the endless stretch.
And the lyre sighed: "I will miss..."
And the lips completed: "the world..."

Shedding the silver-red trace,
The double trace in red silver,
In the swooning Gebr—*
My beloved brother! My sister!

At times, in unquenchable longing
The head slowed down.
But the lyre implored: "Float past!..."
And the lips responded: "Alas!"

Brought closer by the distant rippling,
Cradled as with a wedding wreath,
Is it the lyre shedding its blood?
Or the hair—its silver?

Descending the river's staircase
To the rippling pool of its cradle,
To that isle where the nightingale sings
His falsehoods better than ever...

Where are these hallowed remains?
Answer to this, salt water!
Has a bare-headed peasant girl**
Perhaps caught them in her net?

1921

*According to the Greek myth, Orpheus' head flowed down the waters of the mythological river Gebr.
**An alternate version of this line has "lesbian" for "peasant girl." Orpheus' head and lyre floated all the way to the island of Lesbos.

At dawn

At dawn—the most sluggish blood,
At dawn—the most authentic silence.
Spirit takes leave of the stagnant flesh,
The bird takes leave of the cage of bone.

The eye sees the most invisible distances,
The heart sees the most invisible links...
The ear drinks the most unheard-of rumors...
Div is crying over defeated Igor.*

1922

*Prince Igor, a 12th century Russian commander is the main character of the famous Russian epic "The Song of Igor's Campaign." Div is a Russian lmythological figure.

There's an hour for those words

There's an hour for those words.
From the depths* of hearing
Life taps out
Its highest rights.

Perhaps from the shoulder
Forced through by the brow,
Perhaps, from the ray
Invisible in the noon.

Flesh stretched into a useless string
Fallen onto a bedsheet.
A tribute to its own fear
And to its flesh.

The hour of the hottest obstinacies
And of the most quiet appeals.
The hour of landless brotherhoods.
The hour of the world's orphaned.

1922

*Tsvetayeva uses a neologism that means *both* "deafnesses" and "a remote, god-forsaken place."

So, in the destitute daily toil

So, in the destitute daily toil,
In the difficult convulsions toward it,
You will forget the friendly trochee
Of your stoic lover;

The bitter gift of her sternness,
And her ardor hidden under slight reserve,
And that wireless blow
Called distance.

Every antiquity except: give and mine,
Every jealousy except that earthly one,
Every fidelity—but even in a deadly fight
Acting like a doubting Thomas.

My coddled one! Swear by your ancestor's gray hair:
Do not take this runaway under your roof!
Long live the Amazonian alliance
Of unsophisticated ends!

Yet, perhaps amid babble and mutual blame,
Tired of eternal femininities,
You will recall my hand that demanded nothing
And my masculine sleeve,

My lips that claimed no reckoning,
Rights that did not trail after you,
Eyes unacquainted with eyelids
Exploring: light.

1922

Find yourself trusting women

Find yourself trusting women
Who have not adjusted miracle with number.
I know that Venus is the result of handwork;
A craftswoman, I know my craft.

From the high solemnity of mutenesses
To the complete debasement of the soul:
The whole divine staircase—from:
Now I'm breathing—to: now you do not.

1922

Remember the law

Remember the law:
Own nothing here.
So that later,
In the City of Friends,

In that steep
Empty
Sky of the males
—Golden all around—

In the world where rivers run backwards,
On the shore of the river
To take into your phantom hand
The phantom hand of another.

The crackle of a weightless spark,
A burst—a reciprocal burst.
(Hiding the inauthenticity of hands
With a handshake).

O that synchronal splash
Of clothes flat as a sword—
In the sky of all-male deities,
In the sky of all-male fetes!

So, in the midst of your boyishness,
Amidst your equalities,
In the fresh latitudes
Of dawns, in the suntan

Of games, in the dry winds—
Hail to you, dispassionate souls!
In the heavens of Tarpeian steeps,
In the heavens of Spartan friendships.

1922

When, Lord

When, Lord,
Upon my life will descend
The serenity of gray hair,
The serenity of the heights.

When, into the ancient silence
Of that first blue...—
The high shoulder
That endured all life.

You, Lord, are one,
One and none of you;
How from down-filled beds
I strained after the empyrean blue.

How, with the stubborn lips,
I listened to the sleep-grass...
(Here, on the earth of arts,
They call me a literateur!)

And how I was tormented
By the cartload taxes of lies;
How, out of its last veins,
The tree flinched for the first time...

1922

You will have your proof

You will have your proof—wait!—
That, thrown into the hay,
She needed neither glory, nor
Solomon's treasury.

No, wringing her hands behind her head,
—With a nightingale's throat!
Shulamith begs not for the treasury
But for a handful of red clay.

1922

The Sibyl

The sibyl: burnt out; the sibyl: charred.
All the birds are dead but god is alive.

The sibyl: emptied out; the sibyl: a drought.
All veins have withered: the jealous groom.

The sibyl: dropped out; the sibyl: the crater
Of fate and destruction—the tree among maids.

Like a regal tree in the naked woods—
At first, the fire howled just like a tree.

Then, from under its lids—taking off, unaware,
Like rivers gone dry, the god took flight.

He sensed the waste of an outside search,
And his voice and his heart fell into me.

The sibyl: the oracle; the sibyl: the vault.
Thus, Annunciation came true in that exact

Unaging hour; thus, in gray-haired grass
Her mortal maidenhood became the cave

For the marvelous voice...
 thus, becoming a starstorm—
The sibyl: dropped out of life.

1922

Sibyl—to the Newborn

Cling to my chest,
Infant:
Birth is the fall into days.

From the cloudy nowhere cliffs
How low
My infant fell.
You were a spirit, you became dust.

Cry, little one, for them and for us:
Birth is the fall into hour.

Cry, little one, again, anew:
Birth is the fall into blood,

Into dust,
Into time...

Where is his miracles' splendor?
Cry, little one: birth into weight;

Into blood,
Into sweat...

You shall rise yet! What they call death
in the world—is the fall into heaven.

You shall see yet! What they call closed eyes
in the world—is the birth into light.

From now
Into forever.
Death, little one: not to sleep, but to rise,
Not to sleep, but to return.

Swim, little one! One staircase step
Behind you...
 —The ascent into day.

1923

But even the joy of mornings

But even the joy of mornings
Is too small for the two.
Having pressed forth with the brow
And gone inside

(For the spirit is a vagabond
And wanders alone)
Bringing your ear down
To the primal clay—

Over the stream
Listen—listen, Adam,
To what the water's flowing veins
Say to the shore:

You are the way and the goal.
You are the footpath and home.
No land is discovered
By two.

You are the bridge and the blast
Into the empyrean league of brows.
(God is a tyrant, jealous
Of all others).

Over the stream
Listen—listen, Adam,
To what the water's flowing veins
Say to the shore:

Beware of the servant
So that, in the proud hour of the horn,
Not to come as a slave
To your father's door.

Beware of the wife
So that, in the horn's naked hour
You won't stand adorned with rings—
Already freed of the flesh.

Over the stream
Listen—listen, Adam,
To what the water's flowing veins
Say to the shore:

Beware! Do not build
on the kinship of heights.
(For, in our heart, *he*
is firmer than *she*).

I tell you, do not covet
The eagle—David is still
Mourning
The one who fell upwards.

Over the stream
Listen—listen, Adam,
To what the water's flowing veins
Say to the shore:

Beware of graves:
More famished than sluts!
The dead lived and have rotted.
Beware of tombs!

Yesterday's truths fill the house
With stench and filth.
Even the ashes
Give way to the wind.

Over the stream
Listen—listen, Adam,
To what the water's flowing veins
Say to the shore:

Beware...

1922

From Trees

VI

Neither with paint, nor with a brush.
Light is his kingdom: his hair is gray.
The red leaves tell lies.
Here—light tramples color.

Color is trampled by light.
The heel of light crushes the chest of color.
Isn't it in this, in this—
The secret, the strength, the purpose

Of the autumn woods?
As if a curtain
Over a quiet backwater of days
Has been torn—and, following it, sternly...

As if one envisions one's son
Through the chasubles of partings...
Words: Palestine
and Elysium suddenly come to mind...

The streaming...The transparency...
Through the fine binding of tremblings—
Light, more blissful than death...
And the bonds dissolve...

Autumnal grayness!
You, Goethe's apotheosis!
Much has been sung here
And yet, more's been unwoven.

Thus gray hair shines:
The ancient heads of the family
See the last son off,
The very last of the seven

Through the last door—
With the luminescence of arms outstretched...
(I don't trust color!
Here red is the worst of servants!)

No longer—light:
Shining with a strange luminescence...
Isn't it in this, in
this...and the bonds dissolve.

———————

So the deserts shine.
Having said more than I could:
The sands of Palestine,
The domes of Elysium...

1922

VII

She who slept dreamlessly
Winced and stood up.
Like a seeing rock
In the strict gradation of a psalm—

Hosts of awakening bodies:
Arms!—Arms!—Arms!
Like an army in a shower of arrows
When it's ripe for torture.

Scrolls of chasubles sheer as meshes
Falling apart like dust.
Hands covering groins
Of virgins and, lash-like,

Shameless hands of old men...
The bird of a youngster's hand...
Cavalry at the horn of Judgment!
The gray-bearded take-off

Standing up waist-high
From under the burial shrouds:
We are a migration! A legion!
A whole nation

Of spectres!—Mercy or damnation!
See! Be! Recollect!
...A handful of trees running up
The hill, at nightfall.

1922

VIII

Someone's heading for a fatal victory.
Trees gesture like tragedies.
Sacrificial dance of Judea!
Trees flutter like sacramentals.

This—a conspiracy against the era:
Against weight, number, fraction, and time.
This—a veil torn apart:
Trees kneel like tombstones...

Someone's arriving: Heaven is the entrance.
Trees salute like festivals.

1923

IX

What revelations,
What truths,
What do you rustle of,
The floods of green?

With sacraments
Of what raving sibyl,
What do you rustle of,
What do you rave about?

What's in your fluttering?
But I know—you cure
With the cool of eternity
The offense of time,

Rising as a youthful
Genius, you disparage
With the finger of absence
The falsehood of sight.

So that, as before
Earth only *seemed* to us.
So that plans were enacted
Only under closed eyelids.

So that we didn't boast
Of the coins of miracles.
So that mysteries were enacted
Only under closed eyelids.

And away from things solid;
And away from things rushed!
Into the torrent: oracles
Through obscure words...

Was that the leaves' rustle?
Was that the sibyl's cry?
...The leafy torrents,
The ruins of leaves...

1923

These are ashes of treasures

These are ashes of treasures,
Of pain and loss.
Faced with such ashes,
Granite turns to dust.

A dove, naked and taintless,
Alive, yet matchless.
These are Solomon's ashes
Above the great vanity.

The menacing chalk mark
Of the dawnless age.
God's at my doorstep
If my house is burned.

Unsmothered by rubbish,
Lord of dreams and of days,
My spirit—like fire—
Out of my gray hair flies!

My years, you did not betray
Me into backing down.
This gray hair is the victory
of immortal powers.

1922

The gold of my hair

The gold of my hair
Lapses into grayness, meekly.
Do not pity me! It has transpired:
My chest has welded all in singing.

Singing—distances are joined
In the country chimney's moans.
Lord! My soul has emerged:
My main and most secret purpose.

1922

God

I

Face without appearance;
Strictness; charm.
All those who shared their chasubles
Sing together in you.

With fallen leaves,
With crumbling brick...
All who cried out
Have fallen silent in you.

Victory over rust—
Over blood—over steel.
All who lay supine
Have risen in you.

1922

God

III

You will not tie him down
To your weights and signs!
Like the slenderest gymnast—
Through the tiniest chink...

God is fleeing us
With the migratory flights,
With the drawbridges,
And the telephone poles.

You will not train him
In fate and distress!
In the sedentary slush of feelings
He is a gray-haired ice drift.

You will not overtake him!
In a domestic flowerpot
God does not sprout leaves
Like a tame begonia!

Under the vaulted dome,
All of them—poets and pilots—
Waited for the voice and the builder.
Hopelessness embraced them all.

For He is the speed—ever running.
For the infinite book of the stars—
from A to Z—
Is but a trace of his cloak!

1922

Do not call out to her

Do not call out to her:
Your call is a whiplash to her; your hail,
Like a haft-deep wound.
She is stirred down to her organ

Depths: the creative dread
Of intrusion; fear her: from her heights
(All fortresses stand upon chasms)
She might yet sing like an organ.

Will you withstand it? The mountain is
Steel and basalt; but, like an avalanche in the azure,
She will sing out with the full voice of the storm
In response to your seraph's alto.

It will come true! Fear it! A fall
Into the last hundredth! Hear!
—I retaliate for the singer's guttural call
With the organ tempest.

1923

Ophelia—In Defense of the Queen

Prince Hamlet! You've had your share of grubbing
Worm-eaten coffins! Here are roses, look!
Think of her who, for the sake of a moment,
Now counts each day that remains.

Prince Hamlet! You've had your share of shaming
The womb of the Queen! It's not for a virgin
To judge passions! No guilt is heavier than Phaedra's.
Still, she is sung by the poets.

And will be! While you, with your mix of lime
And decay...Go tattle it to dead bones,
Prince Hamlet! It's not in your power
To judge the impassioned blood.

But if...Then beware! Through the floor slabs—
Into your chamber—to my heart's content—
I will rise to the defense of the Queen of Denmark,
I, your immortal love.

1923

It's no black magic

It's no black magic. I have sharpened my
Sight in the white book of the Don.
Wherever you are, I shall find you,
Suffer you out and will you back.

From my pride, as if from a cedar
I behold the world: ships sail on,
Fires are rampant...I shall scour
The sea-depths; I'll will you back from the sea!

So suffer my search. For I'm in all:
I am breath and bread, dawn and ore.
I am; I shall be; I shall have your lips
As surely as god will have your soul.

By way of breath...in your gasping hour
I shall leap over the wall of the archangel's
Court. All blood from my lips I will give
To the thorns—and will you back to life.

Yield now. It's not the hour for fairy tales.
Yield now. The arrow has made its full circle...
Yield now. No one has yet been rescued
From the one who takes all without touch:

By way of breath...(Breasts fling upward,
Lids are blind, foam around lips...)
Like Samuel's sorceress, I'll coax you
Out, and yet, shall return alone.

For another is with you, and the Judgment day
Is no time for a contest...I last and last.
I am and I shall be; I shall have
Soul...as your lips shall be snatched

By the mourning keeper of lips...

1923

The hour when the kings on high

The hour when the kings on high
Bear gifts each to each
(The hour I descend the mountain):
The mountain begins to see.

Plots densely crowd the circle.
Fates draw together: no escape.
The hour I don't see my hands:

The souls begin to see.

1923

The hour when my dear brother

The hour when my dear brother
Passed the last elm
(Sweeps of an arm lined up in a row)
Tears were larger than eyes.

The hour when my dear friend
Skirted the last headland
(Of soundless sighs: "Come back!")
The sweeps were larger than arms

As if—to follow him—the arms broke away from the shoulders!
As if lips—to follow him—cast a spell!
The hand lost its fingers,
The speech lost its words...

The hour when my dear guest...
—Look at us, Lord!—
Tears were larger than human
Eyes and the Atlantic
Stars...

1923

As patiently as stones are chiseled

As patiently as stone is chiseled,
As patiently as death is expected,
As patiently as message is ripening,
As patiently as revenge is cherished,

I will wait for you (fingers writhing,
Like a consort awaiting his Empress.)
As patiently as a rhyme is expected,
As patiently as hands are gnawed.

I will wait for you (eyes downward,
Teeth biting lips, numb, like a rock.)
As patiently as pleasure is drawn out,
As patiently as pearls are strung.

The creak of the sled, the echoing creak
Of the door, the roar of the taiga winds.
The imperial decree has come down;
A new reign dawns—the king is here.

Welcome,
Unearthly home it is,
But mine.

1923

With the others

With the others—into the pink heaps
Of breasts...Into the conjectured fractions
Of weeks...
 While I'll remain for you
The treasury of semblances

Gleaned by chance, in sand, in the shattered
Brick, overheard in the wind, in the railroad
Tracks...Passing by all the destitute
Gates where our youth has walked.

Do you recognize the shawl? Wrapped tightly
With cold, thrown open
Hotter than hell...
 Know that the womb-
Miracle is under this lap: the living infant:

Song! With this first-born better
Than any first-born, or any Rachel...
—With my imaginings I shall master
The most authentic thickets of the womb!

1923

Window

With the Atlantic, delightful
Breath of spring—
Like a huge butterfly
My curtain flies—and

Like an Indian widow
Into the golden-mouthed chasm,
Like a sleepy naiad
Into the beyond-the-window seas...

1923

Sister

Hell and Heaven are not enough:
They are already dying for you.

Following the brother into his fire—
Is it customary? Not a place for
Sisterly love, but for the flame-red passion.
With the brother, under the burial mound...
Is it customary?
 "He was mine and will always be! Even if rotted
away!"

—This is the grave's supremacy!

1923

The hour of bared riverheads

The hour of bared riverheads,
The hour when we look into souls as into eyes.
This—the yawning sluice-gate of blood.
This—the yawning sluice-gate of night.

Blood gushes forth like a torrent of night
Blood gushes forth—like a torrent of blood
The night gushes forth! (The hour of listening sluices:
When the world gushes through ears as if through eyes)

The pulled-off shroud of vision!
The distinct lull of time!
The hour when, having opened our ears like eyelids,
We no longer weigh, nor breathe: we listen.

The world has acquired the shape
Of an ear: the shell that sucks in
Every sound—a sheer soul!
(The hour when we walk into souls as into arms).

1923

To Steal By...

Perhaps, the best victory
Over time and gravity
Is to pass without a trace,
Without having even cast a shadow

On the walls...
 To reject it all
Perhaps; to erase one's image from the mirrors;
Like Lermontov in the Caucasus,
To steal by without stirring up the rocks?

Perhaps, it would have been more droll
Not to have touched the organ echo
With the finger of Sebastian Bach;
To dissolve, without having left dust

For the urn?
 Perhaps, to lie
One's way out; to get discharged from latitudes;
To steal through Time as through an
Ocean, its waters left unstirred...

1923

The Dialog of Hamlet with His Conscience

She lies on the bottom, with silt
And weeds...She went there
To sleep—but even there sleep escapes her.
 —But I loved her
More than forty thousand brothers!
 —Hamlet!
She lies on the bottom, with silt.
Silt! and her last petal
Is awash on a log in the stream.
 —But I loved her
More than forty thousand...
 —Less though,
Than one lover.

She lies on the bottom, with silt.
—But did I
 (bewildered)
 love her?

1923

The Crevasse

Neither friendship nor love will know
How this history ended.
Each day your answer is more muffled,
Each day you are sinking deeper.

No longer ruffled by anything—
Only a tree branch swaying—
Fallen into a glacial crevasse:
Chest that has crushed against you *so*!

Out of the storehouse of semblances
Pick out—at random—your augury:
You sleep in me as in a crystal
Coffin, you sleep in me

As in a deep wound—the crevasse is tight!
The glacier, jealous of its dead:
A ring, a shield, a seal, a belt,
Without return and without answer.

Widows, you curse Helen needlessly!
It's not in the fire of Helen's
Red Troy!—but in the blue of the glacial
Crevasse at whose bottom you sleep...

Having mated with you like Aetna
With Empedocles...Fall asleep, dreamer!
And tell your family it is all in vain:
This chest does not relinquish its dead.

1923

The Curtain

The waterfall of the curtain has roared
Like foam; pine needles; like flame.
The curtain hides no secrets from the stage.
(The stage is you; the curtain—me).

With the dreamed-up thickets (stupor
Floods the spacious hall),
In his struggles with destiny, I conceal the hero,
The place of action and of time.

With the waterfall rainbows, with the shower
Of laurels (you've entrusted yourself to me: you knew it!)
I shield you from the audience,
I charm the hall.

Mystery of the curtain! With the dreamed-up forest
Of sleep remedies, grass, grains...
(Behind the shuddering curtain
The tragedy proceeds like a storm).

Rows, shed tears! Sound alarm, tiers!
Lot, come to pass! Hero, be!
Sail-like, the curtain surges.
Chest-like, the curtain swells.

Out of my last heart, depths,
I shield you.—Blast!
Over stung Phaedra
Like a gryphon, the curtain flies.

Take it! Rip it! See how it gushes forth!
Prepare your vats!
I'll give away every drop of this regal wound,
(The audience is white; the curtain, red).

Then, swishing like a compassionate veil,
Like a flag: downwards...
The curtain holds no secrets from the audience.
(The audience is life, the curtain—me).

1923

Sahara

Do not search, handsome lads!
Stifling him with sands,
The soul won't tell
Of him who is missing.

You search in vain, handsome
Lads—I'm telling the truth!
He who is missing rests
In a safe coffin.

With his poems as if with lands
Of miracles and of fire,
With his poems as if with countries
He rode into me:

Arid and sandy,
Fathomless, dayless.
With his poems as if with lands
He vanished in me.

Listen, without jealousy,
To this story of souls.
The sandy drought—
Into the oasis of eyes...

The beseeching throb
Of the Adam's apple...
I grasped him death-tight
Like passion and God.

Nameless, he vanished!
Won't be found. Taken.
Deserts have no memory—
Thousands sleep in them.

The upwelling waves
Quieting down as foam.
Buried under the sand:
Sahara is your mount.

1923

From The Hour of the Soul...

In the Inmost Hour of the Soul

1

In the inmost hour of the soul and the night
Unmarked on the clock,
I looked in a youth's eyes
Unmarked in anybody's

Nights, reposing
—Without recall and without end—
Like a double millpond. From here
Your life begins.

The look of a gray-haired she-wolf
Who in her suckling envisions—Rome.
The visionary motherhood
Of the rock...There's no name for all of my

Losses...Having cast off every
Covering—grown out of losses!—
Thus, the daughter of Egypt
Bowed, once upon a time, over the reed

Basket...

1923

2

In the inmost hour of the soul

In the inmost hour of the soul,
In the inmost one—of the night...
(The gigantic stride of the soul,
Of the soul in the night)

That hour, soul, reign
Over the worlds you desire.
To rule is the lot of the soul:
Soul, reign.

Cover the lips with rust; snow lightly
Upon the lashes...
(The Atlantic sigh of the soul,
Of the soul in the night...)

That hour, soul, darken
The eyes in which you will rise
Like a Vega...make bitter
The sweetest fruit, soul.

Make bitter: darken:
Grow: reign.

1923

Beyond Sight

Reciprocity, do not obstruct
The Castalian flow.
Nonpresence: the greater substance
Lying beyond the eye;

Beyond speech, beyond sight,
Like a prolonged *la* note
Stretching out miles of distance
Between the temptation and the lips.

Blessed are the longitudes,
The latitudes of Lethe and zones!
Furthering into you with distance
As with the whole note; stretching out

Into you like a moan;
Striking against you like an echo
Into the chest of granite:
Do not see, do not hear, do not exist—

I've no need for white
Upon black—the chalk of the blackboard!
Nearly beyond the confines
Of soul, beyond the limits of pain—

...The last card of my verbal arrogance
Has been dealt.
Distance, you are now nothing but
A blank wall to me.

1923

Minute

Minute: the disappearing one: you will pass.
Pass me by then, passion and friendship!
What tomorrow would tear away from my hands
I throw out today!

Minute: the measuring one! Cheating
On the most minute detail! Listen:
That which ended—
Never began. Lie then, flatter

Others, still subject to the measles
Of fraction, still not grown out of
Deeds. Who are you, to squander
Away the sea? The watershed

Of a living soul? O trinket! O trifle!
The glorious King of Bounties
Had no kingdom worthier than
The legend on his ring "This, too,

Will pass..." On their roads back
Who did not plumb the vanity
Of your clock-faced Arabias,
Of your pendulums' toil?

Minute: the torment! The racing illusion:
Still lingering! Grinding us
Into trash and ashes! You that will pass:
Minute: charity to the dogs.

O how I long to leave the world
Where pendulums rend the soul,
Where the succession of minutes
Rules my eternity.

1923

From this mountain

From this mountain as from
A roof of the world that descends to Heaven,
Friend, I love you above
Measures, feelings.

I'll hide you in a storm cloud, away
From witnesses. I'll devour you with ash.
...From this mountain as from the red
Walls of Troy.

Passion: praising the dead,
Shame to the ones still living.
This is how Priam the King
Looked at the battlefield.

All foundations are down.
Fire? Aura? Blood?
This is how Olympus
Looked down at Troy.

No, from the cool niche
A virgin stretches out her arm...
Friend, I love you from above.
Hear me and—rise.

1923

The Ravine

You will never learn what I burn, what I spend
 —A heartbeat—
On your tender, empty, warm chest,
Dear snob.

You will never know the traces of what alien
Storms you have kissed away!
Not a mountain, nor a ravine, nor an embankment:
The mountain-path of the soul.

Do not listen attentively! It's but the quicksilver
Of cruel delirium. River words...
You are right to be taking me blindly. Such victories
Can tear arms off your shoulders.

Do not look intently! Under the falling leaves
We ourselves rush like leaves.
You are right to be taking me blindly. These are but clouds
Rushing after the slant rain.

Lie down—and I will, too. Good. All's for the good!
Like bodies in the war—
Lined up, unanimously. Are we in the ravine's depths
Or perhaps in the depths of the sky?

In this insane race of the sleepless trees
Somebody's done for.
Young David, do you know your victory
Is the legions' defeat?

1923

I love you, but the torment is still alive

I love you, but the torment is still alive.
Find the lullaby words to soothe it.

Rainy words, words that are spendthrift.
Make them up yourself; so that, in their leaves,

Rain dribbles: not a flail thrashing grain:
Rain drumming the roof: streaming down my brow,

Down my coffin, so that my coffin lit up,
My fever calmed, somebody slept

On and on...
 They say that water
Seeps through the chinks—People
Lie in rows, without a moan, waiting
For the unknown. (They will burn—me).

Rock me to sleep, but I ask of you:
Not with letters—with the shelter of your hands,

With softness...

1923

You who loved me with the falsehood

You who loved me with the falsehood
Of truth—and with the truth of falsehood;
Who loved me to the limits
Of the possible—beyond all limits—

You who loved me longer
Than Time—one sweep of an arm!
You no longer love me:
These five words are the truth.

1923

There are rhymes in this world

There are rhymes in this world.
Disjoin them, and it trembles.
You were a blind man, Homer.
Night sat on your eyebrows.

Night, your singer's cloak.
Night, on your eyes, like a shutter.
Would a seeing man not have joined
Achilles to Helen?

Helen. Achilles.
Name a better sounding match.
For, in defiance of chaos
The world thrives on accords.

Yet, disjointed (with accord
At its core) it seeks revenge
In wifely unfaithfulness
And the burning Troy.

You were a blind man, bard.
You littered fortune like trash.
Those rhymes have been forged in *that*
World, and as you draw them apart

This world crumbles. Who needs
An accord! Grow old, Helen!
Achaia's best warrior!
Sparta's sweet beauty!

Nothing but the murmur
Of myrtle, a lyre's dream:
"Helen. Achilles.
The couple kept apart."

1924

It is not fated

It is not fated that, in this world,
The strong join the strong.
Thus, Siegfried parted from Brunhilde,
A sword stroke instead of marriage.

In the allied brotherly hatred
—Like buffalos!—rock challenging rock.
Unknown, he left the marriage bed,
And, unknown, she slept.

Apart; even in a marriage bed,
Apart; even with joined fists,
Apart; in the two-pronged language
Too late and apart: this—our marriage!

But there's a more ancient offense than
That: lion-like, crushing the Amazon,
The son of Thetis parted from
Ares' daughter: Achilles

From Penthesilea.
 O recall her look
From the ground—the look of a fallen
Rider! No longer down from her Olympus:
Up from the slush, yet still looking down at him!

His only jealousy now is this:
To seize her alive from the dark.
It is not fated that the strong join the strong...

—This is how you and I part.

1924

The Island

There's an island—snatched away from Nereids
With an underground shock;
A virgin—tracked down
By no one: undiscovered.

It overflows with fern. It hides
In sea foam. The route? The tariff?
I know only: it is listed
Nowhere except your

Columbus' eyes. Two palm trees
So clearly seen!...Gone. A condor's
Wing flapping...
 (Enough about your
Islands!—in a sleeping car!)

One hour, or perhaps a week
Of sailing (a year—if I insist!)
I know only: it is listed
Nowhere except in latitudes

Of the future...

1924

Under the Shawl

Engraved like an oracle's mouth—
Your mouth that divined for multitudes.
Woman, between your tongue and your palate,
What did you hide from the guards?

Into eternity—no longer with eyes but with holes,
With a bucket cauldron.
Woman, what chasm have you dug
And covered with turf?

An idol presiding over a hundred shrines
Would not be as arrogant.
Woman, what have you grasped from the fire
Of caresses, the two-night loves?

Woman, you widen in secrets as in shawls,
You last in shawls as in secrets.
Set apart—lucky one:
A fir tree on a hazy peak.

I throw questions at you as at one deceased,
A soul that has drunk from the roots.
Woman, what is under your shawl?
—The future.

1924

Thus—only Helen looks past the Trojan

Thus—only Helen looks past the Trojan
Roofs. In the stupor of her eyes
Four provinces left bloodless
And a hundred centuries forlorn.

Thus—only Helen, towering above the marital strife,
Thinks: my nudity
Has left four Arabias frozen
And five seas drained of pearls.

Thus only Helen—do not expect to see
Her wringing her hands!—wonders at this host
Of crown princes left homeless
And chieftains rushing to fight.

Thus only Helen—do not expect to see
Her pleading lips!—wonders at this ditch
Heaped up with princes:
At the sonlessness of a hundred tribes.

But no, not Helen! Not that bigamous
Thief, the pestilential draught.
What treasury have you squandered
That you now look into our eyes as

Even Helen at the great supper
Did not dare—into the eyes of her slaves:
Gods. "The land left husbandless by an outsider
Still, like a caterpillar, groveling towards her feet."

1924

The Baptism

He did not overwarm the water
In the vat, but chilled it,
That priest who baptized me
In the flat-bottomed wedding ladle.

He did not oversweeten the wine—
(The soul shouldn't meddle with drink!)
The priest who baptized me
For this difficult marriage,

That priest who wedded me.
(When she was burned, the dancer understood
It wasyour juice, Anchar tree,*
She tasted from the

Ladle...)
　　　—For the eternal ardor
In the poets' pitchstone oven
He baptized me, who dipped me
Into the icy river

Water. For the superhuman
Feats, not essayed by women
He baptized me, who dipped
Into unsweetened misfortune,

That unalloyed wine.
When I choke with it—remind him!
What fire can scorch me now?
All passions are as tepid

*A poisonous tree in Pushkin's poem of the same title.

Water. He was three times right,
That priest who sheared me.
What poison can stop me now?
All poisons are as broth-like

Water. What's fate for me
—With its ancestral fears—
If the tears streaming down
My cheeks are sweet water?

And you, who baptized me
With Saul's frenzied water
(Thus, Saul, raising his crutch,
Stopped the forgetful people)—

Go and beg your Lord
For forgiveness.

1925

Squeezed with the hollows

Squeezed with the hollows
Of existence, in a stupor of backwoods,
Buried alive under the avalanche
Of days, I serve my sentence in life.

My tomb-like, forsaken wintering.
Death: frost on my red lips—
No health other than this
I ask from God and from spring.

1925

A soldier—into a trench

A soldier—into a trench,
a head of hair—into grayness.
Sky! I blend with you, sea-like.
On every syllable
As at a secret look,
I turn,
I preen.

A Scythian—into a skirmish,
A whip—into wild dance.
Sea! I brave into you, sky-like.
In every poem
As at a secret catcall
I stop,
I listen.

Every line cries: "Stop!"
A fortune in every period.
Eye! I melt into you, light-like;
Go loose. Like a guitar
Anguish,
I reshift myself,
I reshape myself.

Marriage is not in swan's down
But in swan's feather!
There are different marriages, disjointed ones!
At the sight of a dash
Like at a secret sign,
Eyebrows twitch
Mistrusting what?

Away from the thin soup of glory
My spirit grew strong!
And my treasury is full!
Like the bread of the Lord,
Under your touch,
I grind myself anew,
I break myself in half.

1925

My veins slashed open

My veins slashed open: unrestrained,
Unrestorable, my life gushes forth.
Hold steady your plates and your bowls!
Each bowl soon will be shallow,
The plates—too flat to contain it.
 Up the brim and *over*
Staining earth dark, nourishing reeds.
Irreversible, unavoidable,
Unrestorable, the poem streams.

1934